Jewels of the Navajo Loom

Teec Nos Pos

to the weavers of
TEEC NOS POS

Teec Nos Pos

Jewels of the Navajo Loom:

The Rugs of Teec Nos Pos

SHED
ROD

HEDDLE
ROD

BATTEN

WARP
YARNS

EDGE
CORDS

WEFT
YARN

Ruth K. Belikove

Museum of Indian Arts & Culture, Santa Fe, New Mexico

Teec Nos Pos

Major support for this book was provided by MIAC RainMakers,
a Museum of New Mexico Foundation support group for the
Museum of Indian Arts & Culture.

Author: Ruth K. Belikove
Exhibit Curator: Duane Anderson
Introduction: Andrew Nagen
Editor: Jo Ann Baldinger
Photography: Robert Sherwood
Catalog Designer: Mike Larkin

ISBN 0-89013-455-3

Printed by Roller Printing, Santa Fe, New Mexico

cover photo:
Design element from Teec Nos Pos double saddle blanket in Plate 11.

title page:
Illustration of Navajo weaving loom courtesy SAR.

Teec Nos Pos

Contents

Teec Nos Pos

Foreword

One of the most complex regional rug styles to to come out of the Navajo Reservation emerged in the area around Teec Nos Pos Trading Post in northeastern Arizona during the first half of the twentieth century. These intricate, colorful rugs, many of which were quite large, have captivated the imagination of dealers, collectors, and museum professionals for nearly a century. Ruth Belikove meticulously gathered her outstanding collection during the 1970s. Her rugs have been exhibited previously at the Nelson Arts Center at Arizona State University, the California Academy of Science, Ohio University, the Grace Hudson Museum in California, and the Yager Museum in New York. The exhibition catalog "The Rugs of Teec Nos Pos: Jewels of the Navajo Loom" was written by Ruth Belikove and published by Alexander Anthony through his Adobe Gallery in Albuquerque.

Ruth came to visit me in Santa Fe during the summer of 2002 to get acquainted and to tell me about her collection. I was quite impressed with the assemblage and was anxious to find some way to bring the show to Santa Fe. Opportunity knocked in December 2002, when our long-planned exhibition of Tewa culture had to be postponed. We quickly reviewed our options and saw the Teec Nos Pos exhibition as a perfect fit for our available gallery space. I think Ruth was in total disbelief when I called to tell her that we not only wanted to do the Teec show, but also wanted to have it up, with the catalog completed, in three months. The next thing she knew, the art handling company was knocking on her door in California, and the rugs were on their way to New Mexico.

In between regional travel and a trip to Australia, Ruth supplied images of the rugs, read manuscript and label copy, and quickly agreed to a number of proposed adjustments to the catalog in support of our quest to further accentuate the beauty and superior quality of these fine textiles. The result is a truly magnificent and inspirational exhibition that will educate and entertain thousands of visitors during its yearlong run at the Museum of Indian Arts & Culture. If you are not already a Teec Nos Pos fan, well, it's just a matter of time.

Duane Anderson, Director
Museum of Indian Arts & Culture
Santa Fe, New Mexico

Introduction

Teec Nos Pos:
A Circle of Cottonwoods

Anyone who has visited the Southwest or spent time on the Navajo Reservation knows the value of a circle of cottonwoods. Cottonwoods mean water, shade, food, fuel, the opportunity to sit and rest, to encounter a fellow traveler, or simply to think, while luxuriating in the welcome shade.

Teec Nos Pos first came to me at my store in 1976, in the form of Bill Foutz. He chewed gum real hard and told me that I had, just *had*, to buy his rugs. "They're the best, Androoo." Wide Ruins layouts with Teec Nos Pos–style panels, Two Grey Hills–colored Teec Nos Pos with Red Mesa outline and geometric field elements. The rugs were mostly woven of commercial yarn, not handspun wool. Bill said that the Navajos shipped their wool to Boston for cleaning, and what came back may not even be the same Navajo wool that they originally sent. Such is the color of the reservation.

It is no surprise that the rugs illustrated in this catalog grew and matured in this particular area of the Navajo Reservation, a circle of cottonwoods. This oasis, with the opportunity for contemplation it provides, fostered the most complex and communicative of all Navajo twentieth-century weavings. Exchange of information is often encouraged among great artists. Upon close examination, one can detect Plains Indian beadwork designs as borders on Teec Nos Pos rugs. The complex geometric field, attributed to the Oriental carpets or photographs made available to weavers, is part of an impersonal exchange. It may be that when you combine a Caucasian rug with a Navajo mind, you get a Teec Nos Pos.

How did this come about? Clearly, marketing considerations must have influenced the traders. The Teec Nos Pos rug offered a quality, appealing product that could reveal or surpass the technical and visual superiority of the Oriental rug. The comparison of Teec Nos Pos rugs to Oriental carpets is irresistible. But is it the point? Do we see parallel development here? With rare exceptions, Navajo Teec Nos Pos rugs communicate something quite different from their antecedents, though obvious homage is paid to their design systems. They radiate intelligence, balance, clarity, and a remark-

Teec Nos Pos

able sense of order, without the jumble of their Middle Eastern cousins.

Not every weaver has genius and courage, so the average Teec Nos Pos rug utilizes repetitive geometric border elements in the field as well as the perimeter. However, the best examples contrast border with field like a movie marquee. What type of woman could begin this new vision? Did her personality or life style allow her creative courage to flow? Parallel development, again, shall we say? The Teec Nos Pos rug most illustrates the continuous thread of the world weaving tradition. How easily the Navajos adapted the Eastern designs to their saddle blankets and rugs!

Teec Nos Pos saddle blankets are popular among collectors and Native Americans and were at the zenith of their production in the years 1910 to 1935. Sometimes composed with a blank center panel, the "fancy" borders of these blankets were natural embellishments on, under, or in place of the saddle. Why not offer your best designs for your closest, most important four-legged companion? Remember, the Teec Nos Pos borders seem closely linked to the Plains Indian design system (which predates Teec Nos

Pos, and also emerged from an equestrian culture). After a Teec saddle, one could not ever return to the ubiquitous, conventional, striped saddle blanket.

Pictorial Teec Nos Pos are rare. Why? Maybe it is because Teec weavers were more oriented to contemporary art and had a unique vision for geometric relationships, rather than folk-art representationalism. Many of the best examples appear to have had advance knowledge, seeming to peer into the future design systems of electronic circuit boards or complex architectural plans. The question I ask inquisitive sellers about their rug is, "Does it look like a wiring diagram?"

I had a large Teec Nos Pos rug, approximately 7x14 feet, that I called the Dash Board of the Star Ship Enterprise. It was hung horizontally, and one was beckoned to turn a lever, twist a dial, or await paper output. I always wondered about the woman who conceived that rug. The timelessness of a piece of art makes it great. Great art from any period will always transcend time. Good yesterday. Good today. Good tomorrow.

So masterful were the Teec Nos Pos weavers that they exceeded

many of the achievements of the earliest Navajo weavers. The best Teec Nos Pos rugs rival the best Classic-period blankets (1830 to 1860). The typical Teec Nos Pos rug is large and narrow, has a unique, complex design system with all elements outlined, often lacks a selvage (warp) cord, and has reinforced warps at number one warp.

Distinct regional Teec Nos Pos weaving seems to have appeared from 1910 to 1915, while Red Mesa development occurred in the 1880s. The Oriental rug influence is obvious in the geometric style, but I see another path. The link in the Red Mesa/Teec Nos Pos style of weaving in its earliest form is the "eye-dazzler," circa 1890s, with a single linear border. After experiencing many Transitional Eyedazzlers, we see the coming of the Red Mesa outline rug. When considering the consummate geometric Teec, can we consider the Transitional Period Germantown dazzlers and the earliest rugs from the Red Mesa area? The Germantowns display precision and balance with multicolor outlining, seen as the twentieth-century Teec and Red Mesa hallmarks. It would seem that the superior Germantown, nonregional weavers

could have parented the regional Teec/Red Mesa weavers and passed along their ideas and talents.

The Navajos were open to letting other cultures influence their design systems. In the early period we see the Mexican influence on the Navajo blanket weavers. When it was time to make the shift to weaving rugs, the Oriental rug design system was a natural source of inspiration. How interesting the ease with which the Navajo nomads incorporated the designs fostered by their Middle Eastern peers. Upon viewing Bedouin costumes, I am taken by the similarity in design to those of the Teec Nos Pos and Red Mesa areas. Could these nomadic people have seen the same geometry in their separate but geographically similar homelands?

In lectures I often refer to "the continuous thread." It is my hope that visitors to this exhibition will come away with a glimpse of one aspect of the continuous thread of the world textile tradition. We have Ruth Belikove to thank for this opportunity.

Andrew Nagen
Old Navajo Rugs and Blankets
Corrales, New Mexico

The Teec Nos Pos Story

THE TRADING POST

Indian trader Hambleton Bridger Noel said that Black Horse "was the finest looking man I ever saw, but he had the disposition of a devil!"[1] The influential Navajo, who was neither a chief nor head of a clan and who disliked white men, controlled the territory where Noel planned to establish a trading post in 1905. Ten years earlier, Black Horse had driven away two prospective traders. Now, several years after Hamp Noel first came to the Southwest, he traveled alone and unarmed across the Arizona desert with a wagonload of trade goods. Probably setting out from Fort Defiance, he eventually arrived in a canyon boasting an abundance of cottonwood trees on T'iisnasbas Creek. Here he founded Teec Nos Pos — Navajo for "cottonwoods in a circle."

The Navajos already had had word of Noel's coming. Upon his arrival, he estimated that 1,000 to 1,500 Indians (although Frank McNitt thinks it was probably more like several hundred) gathered in the canyon to decide if they wanted this slight, boyish-looking white man to live among them. The discussion took most of the day. Noel said, "I gave them food for a big meal, flour, a few muttons, and coffee. The squaws cooked it."[2] And they feasted. By evening, the Navajos had agreed to allow him to build a trading post.

Meanwhile, Black Horse arrived to see what was going on. When he saw Noel, he recognized him as the *biliganna* (white man) who had befriended him when he was sick and hungry a few years before at Chaco Canyon. Black Horse, an impressive six-footer, had a dynamic, charismatic personality and dominated any space he occupied. He was an impassioned speaker. "When he talked at meetings, his words carried weight," Noel said.[3] Black Horse spoke in favor of Noel.

One of Noel's other strong supporters was Tribal Judge Clah-Chis-Chilli (Left-Handed Curly Man), who thought that Hamp Noel would be fair with the Indians. They knew and respected Frank Noel, Hamp's older brother, for his honest dealings as a trader at neighboring Sa Nos Tee Trading Post. Clah-Chis-Chilli also pointed out the convenience of having a local trading post—the people would not have to travel in bad weather to buy goods or sell sheep, wool, and hides.

Hamp Noel, like his father, was born on a plantation near Tappahannock, Virginia, which had been in the family for decades. The elder Noel, a surgeon who served with the Confederate Army during the Civil War, died of tuberculosis at the age of fifty. Hamp's mother, Clara, who

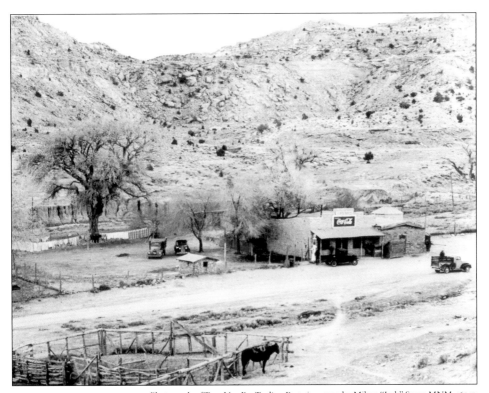

Photograph of Teec Nos Pos Trading Post circa 1949 by Milton "Jack" Snow. MNM 46042.

came from a prominent Baltimore family, ran the plantation until her own death from tuberculosis in 1891. The family was uprooted, and Hamp's three older brothers went west, to the Four Corners area. Hamp, who had been living in Baltimore, joined them in 1898. "In Baltimore," he said, "I lived right above a busy street with street cars and all kinds of traffic going by far into the night. I was used to the noise and could sleep like a baby. Out

here the silence was too much for me."[4]

Hamp Noel was already weakened by tuberculosis. The dry air of New Mexico Territory was good for him, and he began to feel better. His choices for making a living were either farming or trading with the Indians; he chose the latter. At Teec Nos Pos, he was the only white man within thirty miles. He lived in a traditional Navajo hogan while the trading post was being built.

Noel found it difficult to trust the

Navajos at first. "When I went out to Teec Nos Pos, it was wild country. I knew I was up against it, but didn't want trouble," he once said. "A drummer [peddler] sold me an automatic-loading, high-powered rifle. I took the Navajos out, and we shot rabbits or pieces of rock high up in the canyon wall. After a lot of this shooting, and letting the Indians see how I could shoot, I hung the rifle up in the post, on the wall in back of the counter, in easy reach and where they could see it. But I never had to take it down in a hurry. There was never any trouble."[5]

Noel's contacts with the outside world were severely limited by the lack of roads to the trading post — it was not until 1959 that a road was built through Teec Nos Pos. Trader John Wetherill sent freight wagons across the northern part of the reservation into Teec Nos Pos, first from Oljetoh, later from Kayenta. The old maps show the route as the Wetherill Trail. Wetherill "sent his loaded wagon to my store, with a return order," Noel recalled. "Then I would fill his wagons from my post and take his goods on to the C. H. Algert Company, wholesale store in Fruitland, New Mexico, using my teams."[6] Betty McGee, Noel's daughter, reported that Hamp also went out in his wagon to sell goods, and at

these times slept with a gun under his pillow.[7]

In 1907, the regional Indian Bureau superintendent, William Shelton, mandated that the Navajos send their children to a government school at Shiprock, New Mexico. They refused to comply. Noel recalled, "Judge Clah-Chis-Chilli and three or four Indians came to see me at Teec Nos Pos to tell me there might be trouble, and then went on to see Byalille, head man of the Navajos in this region, living near Aneth, Utah. I was told that if Shelton sent troops to enforce the school order, Byalille's outfit would rob my store, and with the supplies go to Moonlight, where there was no road within a hundred miles, and hide out. It was implied that they would shoot me and burn my store after robbing it."[8]

Shelton sent for the troops, and just before daybreak, they surrounded the camp and took fifteen to twenty prisoners. Noel said, "I was not there, but the Indians who were told me about it later. One of the Navajos came out of his hogan with a rifle, went up behind a fence, and shot at one of the troopers and missed. The troops then opened fire and killed this man and one other Navajo. I don't think the soldiers had any casualties. All of the Navajos were arrested and put in a prison awhile and then turned loose."[9]

Eventually Noel gained the trust and friendship of the Navajos in the area. He respected and encouraged them, and taught them discipline and courtesy, based on his Mormon beliefs. (He had joined the Mormon church in 1900.) As their teacher, he was able to shape their lives and views of the outside world.[10] In those days, a trader wore many hats — lawyer, doctor, marital counselor, teacher, friend, undertaker, and banker (since most business was done on credit). The trading post was also the local newsroom for the Indians.

In 1911, at the age of 35, Hamp Noel married Eva Foutz. Soon after that he suffered a recurrence of tuberculosis and was confined to bed. From a cot in his living room, he was able to keep an eye on the activities of the trading post through a peephole in the wall. The Noels sold the trading post to Bert Dustin in 1913 and moved their family to a ranch in Fruitland, where Hamp lived to his eighty-eighth year. (The peephole was still in place when Russell Foutz and Ken Washburn bought the trading post in 1940.)

Bert Dustin's purchase of the Teec Nos Pos Trading Post ushered in a new style of ownership. Brothers Bert and Shel Dustin, with their brothers-in-law Al and June (Junius) Foutz, formed a partnership called the Progressive Mercantile Company, which financed many of the traders on that part of the reservation, as well as supplying them with goods. Al Foutz's son, Russell, explained that Progressive would look for a young married man and give him a 25 percent interest to run a post owned by them; eventually he could buy it for himself. Sometimes one of the owners bought a post in his own name. The Foutz family was able to create a trading dynasty in the Four Corners area, at one point owning more than twenty posts.

Throughout the 1920s, the four partners ran Teec Nos Pos by sending two owners at a time for six-month stints. Then Luff Foutz, another of Al's sons, ran the post. In the late 1930s, when money was short, Luff would send the best Teec Nos Pos rugs to the Rocky Mountain Park Company in Denver. Quite a few of these rugs were sold in the Denver area, until Luff died of meningitis in 1939 during an epidemic on the Navajo Reservation.

Ken Washburn, who had worked for Luff for many years, and Russell Foutz bought out Luff's interest, and Washburn ran the post. While Washburn was managing the post in the 1930s, the Navajos rose up in protest of the government's stock-reduction program. Foutz said, "I

Map of area surrounding Teec Nos Pos developed to scale by catalog designer.

think they took the man who was the range rider at that time and they were going to lynch him, but that never happened. At the time this was going on, Earl Saltwater came into the store, told Mr. Washburn about the trouble they were having, and suggested he send his wife to town. Saltwater cut the telephone lines, and Washburn's wife, no longer threatened, was released. When I first went out there to run it, that was one of the first things one of the old-timers came in to tell me. 'I guess you know I went to the penitentiary one time for this uprising here. I wanted to tell you about it before I come in to ask for credit.'"[11]

Ken Washburn left Teec Nos Pos suddenly in 1949. As a result, Russell and Helen Foutz had to take over, moving with their three small children from Fruitland. Helen, who was city-bred, reminisced about their first

day: "The Indians had a nasty habit that when anybody new came as a trader, they tried to make his life just as miserable as possible. Our experience was typical. The Indians, by means of a tom-tom or other device they used, all knew that there was a new man out there. Of course, they were familiar with his name, but that did not make any difference. They weren't familiar with him. They would take to coming in one at a time, buying one item. All of this was charged, of course; in those days it was all on credit. They would come in to buy a can of tomatoes and we would have to write out a slip, hand it to them, and give them their tomatoes. They would go outside for fifteen to twenty minutes, and they would come in to buy a can of peaches, and we would go through the whole process time after time. There were probably three dozen people who came in an average of six times during that day, each buying one item at a time. They were just testing us. But I can remember that we didn't get out of the store that night until 10 o'clock. They would come up to me and tell me what they wanted, that they wanted a sack of flour. I would have to go back into the wareroom to get a ten or twenty-five-pound sack of flour, put it on my shoulder, and sling it over the count-

er. I tell you we were utterly exhausted at the end of that day. Things got better after that, but they had their fun with us."[12]

The Foutz family stayed at the post for several years and then moved to Farmington, New Mexico, sixty miles away. Russell stayed on, assisted by his cousins Jay and Lloyd Foutz, until the latter bought the nearby Beclabito Trading Post.

In 1959, the Teec Nos Pos Trading Post burned to the ground. Thousands of dollars worth of jewelry, blankets, rugs, and other items were lost. A new highway was in the planning stage at the time, so Russell Foutz tried to rebuild the post on the road. Previously, the only access was a dirt road. "That's why it was hard to get there," Foutz said, "and the Model T Fords, with their small tires, would get stuck going in. At this time the Indians had a meeting to decide whether they should let us build a trading post and continue operating there. I remember Fred Todacheenie got up at the meeting while they were discussing it and said, 'All the white men cheat us, but this fellow just cheats us a little bit. I think we ought to keep him and be satisfied with the trader we have.' So there we were, trying to rebuild this trading post on a highway that wasn't even built, it was just surveyed. We would

stake out the post and then they would move the highway, and this went on for several months. We did miss the corner [intersection], and so the post is not on the highway. About the time we got it finished, one salesman came out there to get an order for hardware for the store. He looked around and said, 'I'm glad my boss can't see me. If he could see me writing an order for a store that doesn't have a road going to it, I know I would be fired immediately.'"[13]

Today, the post is still in operation, although the way it does business has changed. The availability of the pickup truck has given the Navajos mobility, so they can comparison-shop their merchandise in other places, both on and off the reservation. No longer beholden to the local trader, they can and do shop for the best prices when selling their rugs.

THE RUGS

With the change in consumer demand from blankets to rugs at the end of the nineteenth century, the Navajo weaving industry had to adapt. The arrival of the railroad meant that ready-made goods were available to consumers at cheaper prices. Handwoven blankets, always important to the Navajo economy, were replaced by manufactured blankets from Pendleton Woolen Mills of Oregon. With rugs so popular in the eastern states, the traders urged the Navajo weavers to serve that market.

The traders also encouraged the Navajo women to create finer pieces, which would bring them more money, and showed them designs that would make their rugs distinctive. For example, according to Betty McGee, her father drew rug designs, emphasized the importance of dyeing the wool, and invited the best weavers to demonstrate their techniques.[14] This may have been innovative on Noel's part, although several other traders, notably Will Evans at Shiprock, painted designs on the inside and outside walls of the trading post, hoping to inspire the weavers to copy them.

The trader wielded enormous influence in the evolution of weaving. Carl Steckel writes, "As a business man, he developed the style and materials and encouraged the best craftsmanship. Equally, he helped shape the taste of the outside world that was paying so well for the rugs. Yet, he did this without losing sight of the fact that he was tampering with a folk art and a cultural tradition of a thousand years."[15]

The Teec Nos Pos Trading Post developed into one of the region's major clearinghouse centers. Two stylistic formats emerged there: an outline style, attributed to Red Mesa,

and a style referred to by traders as geometric, with floating elements on a field. The Navajo women who frequented the post at Teec Nos Pos, according to the Foutzes, were exceptionally good weavers then, and they still are today. Most of the good Teec rugs come from about five families of weavers.

The serrated, zigzag design, done in a vertical format in which every color is outlined with a contrasting color, emerged before 1905 and has not changed to this day. Tyrone Campbell points out that these designs are remarkably similar to the early New England flame stitch, and are identified with neighboring Red Mesa Trading Post.[16] Ann Hedlund says they are "clearly derived from 19th-century Germantown eye-dazzler blankets."[17] Hedlund also credits this style as arising from the bordered geometric patterns when Oriental patterns were introduced to the Crystal and Two Grey Hills communities. Andrew Nagen thinks that the design elements of the styles are based on natural forms: lightning, mesa-like structures, cloud patterns, and arrangements of geographic landmarks.[18]

The unique Oriental rug motifs identified with Teec Nos Pos were said to have been brought to the weavers before 1905 by a Mrs. Wilson, possibly a missionary. (Noel

said that the weavers themselves told him that.) Russell Foutz conjectures that an itinerant artist brought sketches to the weavers, while others credit the influence of J. B. Moore at Crystal Trading Post and Ed Davies at Two Grey Hills Trading Post. Kate Peck Kent writes that this style, using Oriental carpet motifs, "has large geometric figures, often with hooked or fretted appendages arranged on a central rectangular plane and surrounded by wide, patterned borders."[19] The Teec Nos Pos rug, according to Gilbert Maxwell, "is at once the most distinctive and least Navajo of all the reservation's specialized textile types. It is the hardest rug to place in a home . . . because of its complexity of design and abundance and variety of color."[20]

Russell Foutz recalled that men created designs for their wives. "Todacheenie Yazz (Little Indian) drew all the designs for his wife, who was one of the better weavers. Then Slocum Clah's son-in-law, Harry, the youngest one, would draw a lot of designs on paper and keep them in a candy showcase at the store, and all the Indians would pick up or buy the designs that he would draw. The women were protective about their border designs. They would be real unhappy if some other weaver or some other family would use their

Teec Nos Pos

borders. This border was their design and nobody else was supposed to use it."[21] From looking at a rug's border, Foutz could tell which family had produced it, although he might not be able to identify the weaver.

Raising sheep for wool on the reservation has declined over the years. Russell Foutz says that they used to buy about three thousand lambs each year and get three to four hundred sacks of wool. Today, probably only half of the stores on the reservation bother with wool. When Foutz first started buying rugs for Progressive Mercantile, he said, "We weighed a lot of them, and the cheaper rugs we bought by the pound. But you could tell where they came from by looking at the rugs. You can't do that anymore because the Indians move around so much now that they intermingle."[22]

Bill Foutz (Russell and Helen's son, who operates a trading post in Shiprock, New Mexico), says that before the 1940s, almost all the wool used for warp and weft was handspun and hand dyed. After World War II, the weavers used Redheart, a four-ply commercial wool, and three-ply Germantown wool in small amounts, for filler elements. (Germantown is a generic name for the synthetic dyed yarns from mills in Germantown, Pennsylvania, that began arriving by

railroad in the late nineteenth century.) "Unless you wanted to hand-dye all that wool yourself, it's the only wool you could get in vibrant colors," Bill said. "Basically, Germantown is a ply wool. People don't realize that Germantown is a commercial, store-bought, store-dyed wool yarn. They think it was something special. It wasn't. It was stuff you bought right at the Ben Franklin store."[23] The availability of commercial wool was a time saver and made it easier for a weaver to concentrate on the design and quality of her weaving.

Bill Foutz remembers that people have always asked for classy, patterned rugs. "We made these things for other people to buy. That was the whole purpose of it. The Navajos did not own these things, and did not put them in their houses. They were and are made exclusively for export. What was made was influenced by what the trader told them to make, based on what sold well against what didn't sell well. There are a lot of reasons why heavily bordered rugs aren't made, weren't made in great numbers, even then. If you have a rug that's all border, you have no room for the center. The 1930s produced some of the best rug designs, where the weavers used a lot of filler elements. The busier it was, the more money it brought."[24] Russell Foutz sponsored a contest

every year for the best weaving. Inevitably, those rugs with the fullest centers won the prizes.

Regarding weaving standards, Bill Foutz notes, "These rugs have to be perfect. Any flaw that you see might be charming in thirty years, but was a great detriment back then, as it is now, on any new rug. The object was to make them as perfect as could be. You didn't want color changes, warps showing, bleeding, or crooked rugs. You wanted it like a machine could do it. You got the best money. To do it otherwise caused the weaver to suffer. If there was a mistake, she knew that she made it, and she knew that she was going to take a hit on it."[25]

The 1930s and 1940s were the golden age of weaving design at Teec Nos Pos. Nagen points out that the best Teec weavings from the 1930s often exhibit a carded gray field with a bluish cast.[26] According to Kent, Teec rugs of the 1940s are distinguished by unusual geometric motifs, not Navajo in origin, that seem to float on a solid color field. Floating motifs appear as though drawn with black lines on a gray field, often "outlined in bright colors or highlighted by the small spots of color that have earned them the name 'jewel pattern' among collectors."[27] This form has continued to the present day, although, as mentioned above, it is no longer identified solely with the Teec Nos Pos area.

Scholars and collectors in the first few decades of the twentieth century considered Teec Nos Pos rugs to be aberrant to the mainstream of Navajo design development. But since the early 1980s, Teec Nos Pos rugs have surpassed even the famous Two Grey Hills rugs in both price and demand, and are the most popular of the regional rugs.[28] According to Gilbert Maxwell, the Teec rugs have their greatest appeal for the serious collector and could be the classic weaving of the twentieth century.[29]

Teec Nos Pos

Plate 1. Teec Nos Pos Pictorial Rug
Early Teec rugs are characterized by eccentric, and
sometimes multiple, borders. The inclusion of pictorial
elements, in this case corn, one of the four sacred
plants, is rare in weavings from this area.
44" x 64" circa 1915.

Plate 2. Teec Nos Pos Rug
Large amounts of carded camel-colored wool characterize
the early period of Teec weaving, and smaller rug sizes
predominate. Bows and arrows and feathers are
symbols of rain in Navajo mythology.
45" x 69" circa 1915–1920.

Teec Nos Pos

Plate 3. Teec Nos Pos Rug
This textile features black lines connecting filler
elements — a trait commonly found in early
period weavings, circa 1905-1920.
40" x 66" circa 1910-1915.

Plate 4. Teec Nos Pos Rug
This early textile features a large double cross
motif that became popular in the 1930s.
50½" x 84" circa 1910-1920.

Teec Nos Pos

Plate 5. Teec Nos Pos Rug
The design elements and carded gray field in this
textile are the norm, but the large open spacing and
lack of an intricate border suggest a weaver who was
just beginning to experiment with Teec Nos Pos design.
40" x 64" circa 1910-1915.

Plate 6. Teec Nos Pos Rug
In this beautiful example, the weaver has reversed the
normal color arrangement. The field is dark brown (black),
while the border is black on white.
44" x 69½" circa 1915.

Teec Nos Pos

Plate 7. Teec Nos Pos Pictorial Rug
Very few examples of Teec weaving have survived
that include Yei figures (Navajo holy people). Here,
three female Yeis are set against a white ground,
surrounded by feathers. A rare example.
54" x 106" circa 1915-1925.

Teec Nos Pos

Plate 8. Teec Nos Pos Rug
In this rug, the center medallion has been
omitted, and the traditional mirrored medallions
have been enlarged to fill the entire field.
48½" x 72" circa 1935.

18

Plate 9. Teec Nos Pos Rug
This large, luminous floor rug perfectly exemplifies
the exhibition title, "Jewels of the Navajo Loom."
Note the inclusion of ten Vallero stars, a design
element frequently found in rugs from this area.
50" x 106½" circa 1920–1925.

Teec Nos Pos

Plate 10. Teec Nos Pos Rug
This textile is noteworthy for its sophisticated
use of the double cross element.
37½" x 72" circa 1920–1925.

Plate 11. Teec Nos Pos Double Saddle Blanket
The Navajos wove very few double pattern
saddle blankets, and even fewer that can be
accurately attributed to the Teec Nos Pos area.
39½" x 54" circa 1920-1925.

Plate 12. Teec Nos Pos Single Saddle Blanket
These blankets are often referred to as "Sunday
saddle blankets," woven as gifts and trade items.
The decorative fringe and tassels are added after
the piece is removed from the loom.
27" x 35¾" circa 1920s.

Teec Nos Pos

Plate 13. Teec Nos Pos Rug
Rugs of the "golden age" of Teec Nos Pos weaving
feature massive standardized borders with variations
of a back-to-back "U" design on beige, outlined
in black, with accents of red and green. The rug
incorporates a second inner border that
dramatically offsets the center field.
62" x 107" circa 1925-1935.

Plate 14. Teec Nos Pos Rug
This rug features a border design often found
in a more complicated form on Oriental rugs.
Note the pattern of crosses in the center
surrounded by alternating medallion patterns.
42" x 66½" circa 1915-1920.

Teec Nos Pos

Plate 15. Teec Nos Pos Rug
This is an unusual example of a borderless Teec Nos Pos.
It features a large amount of carded brown wool.
52" x 86" circa 1940-1950.

Plate 16. Teec Nos Pos Rug
Toward the end of the "golden age" of Teec Nos
Pos weaving, filler elements become fewer and more
widely spaced. In this example, the elaborate border
offsets the modest field design. The stylized, tulip-like
motifs are a standard Teec design element.
47" x 107" circa 1935–1940.

Plate 17. Teec Nos Pos Runner
During the the 1920s and 1930s, Teec rugs increased
in size, and filler elements became more numerous,
smaller, and increasingly outlined in various colors.
41½" x 103" Circa 1920–1930.

Plate 18. Teec Nos Pos Rug
Large Teec rugs tend to be long and narrow.
The browns and greens in this example are
derived from native vegetal dyes.
63" x 151½" circa 1915–1925.

Teec Nos Pos

Plate 19. Teec Nos Pos Rug
In this Teec rug, an unusual, meandering
second inner border dramatically offsets the
traditional large beige-on-black border.
58½" x 87" circa 1925-1935.

Plate 20. Teec Nos Pos Rug
This rug is a textbook example of a classic Teec border,
with jewel-like elements within the tulip shapes.
As in most rugs of this period, the filler elements
are woven with commercially-plyed wool.
55" x 81½" circa 1925–1935.

Teec Nos Pos

Plate 21. Teec Nos Pos Rug
This small rug has an extremely well-balanced
design with an exceptionally complex border
concept. It was woven with a combination of
native vegetal and aniline dyes.
36" x 63" circa 1915-1920.

Plate 22. Teec Nos Pos Outline Design Rug
The serrated outline style, in which each color is
outlined with a different color, was developed at
both Red Mesa and Teec Nos Pos trading posts.
57" x 90" circa 1930-1940.

Teec Nos Pos

Plate 23. Red Mesa Outline Design Rug
A classic outline design. This style may be a
development of the nineteenth-century Germantown
"eyedazzler" designs, although the similarity to New
England flame stitch designs is plainly evident.
57" x 92" circa 1940–1950.

Plate 24. Red Mesa/Teec Nos Pos
Third Phase Chief Pattern Revival Rug
This is an exceptional example of an outline
design incorporated into the nine anchor points
of a traditional Third Phase Chief Pattern rug.
52" x 78" circa 1910-1915.

Plate 25. Teec Nos Pos Varient Rug
This type of rug is generally included in the Teec
category but exhibits elements from the area of
the Crystal Trading Post. The circular and rosette
shapes, along with the overall complexity of design,
required the skill of a master weaver. Note the
two Yei figures in the center medallion.
75" x 122" circa 1920-1935.

Acknowledgments

This catalog has benefited greatly from the efforts and vision of Heather Lineberry and Marilyn Zeitlin of the Nelson Art Center in 1994, and of Russ Hartman at the California Academy of Science in 1997. The Foutz family, Russell, Helen, Kathy, and Bill, as well as Ruthie McGee, Charles and Grace Herring, and Leland Noel, contributed most to the anecdotal history. Laura Holt and other librarians were equally helpful. Tyrone Campbell introduced me to this world of beauty, helped assemble the collection, and wrote the captions for the textiles in the original edition. Robert Sherwood photographed the rugs for the catalog. Thanks to Ken Feehan and my computer-literate grandchildren, Sasha and Adam Talcott.

I am grateful to Mike Larkin for designing the 2003 catalog, and to Jo Ann Baldinger for her efforts in editing the manuscript. Alexander Anthony, publisher of the 1994 catalog, kindly granted permission to revise and republish it. I am indebted to several members of the Museum of Indian Arts & Culture staff, including Valerie Verzuh, collections manager, Anita McNeece, registrar, Dennis Culver, preparator, John Torres, curator of archaeology, Antonio Chavarria, curator of ethnology, David McNeece, rights and reproductions, Claire Munzenrider and Mina Thompson, conservation department, John Tinker and Luba Kruk, exhibits department, Lisa Tibbs, marketing and public relations, Anna Gallegos and Mary Wachs, Museum of New Mexico Press, and John Stafford, Museum of New Mexico Shops.

This project would not have been possible without a generous gift from the MIAC RainMakers, a support group of the Museum of New Mexico Foundation. Finally, I would like to thank Duane Anderson, director of the Museum of Indian Arts & Culture, for following up on my proposal to exhibit the Teec Nos Pos collection, and for his efforts in coordinating both the catalog and the exhibition.

Ruth K. Belikove

Teec Nos Pos

Notes

1. Frank McNitt, *The Indian Traders*, p. 280.
2. Frank McNitt, interview with Hambleton Noel, Fruitland, New Mexico, January 1958.
3. See Note 1.
4. Jennie N. Weeks et al., *Emigrant Cornelius Noel*, pp. 289-290.
5. See Note 2.
6. See Note 2.
7. Telephone conversation with Betty McGee, Mesa, Arizona, October 1993.
8. See Note 2.
9. See Note 2.
10. See Note 7.
11. Taped interview with Russell Foutz, Farmington, New Mexico, July 1993.
12. Taped interview with Helen Foutz, Farmington, New Mexico, July 1993.
13. See Note 11.
14. See Note 7.
15. Carl Steckel, *Early Day Trader with the Navajo*, pp. 4-5.
16. Tyrone Campbell, *The Teec Nos Pos Regional Rug, 1905-1945*.
17. Ann L. Hedlund, *Reflections of the Weavers' World*, p. 42.
18. Conversation with Andrew Nagen, Corrales, New Mexico, December 1993.
19. Kate Peck Kent, *Navajo Weaving*, p. 89.
20. Gilbert Maxwell, *Navajo Rugs*, p. 23.
21. See Note 11.
22. See Note 11.
23. Taped interview with Bill Foutz, Farmington, New Mexico, July 1993.
24. Ibid.
25. Ibid.
26. See Note 18.
27. See Note 19.
28. See Note 16.
29. See Note 20.

Bibliography

Anderson, Lowell Edgar. "Factors Influencing Design in Navajo Weaving." Master's thesis (Decorative Arts), University of California–Berkeley, 1951.

Belikove, Ruth. *The Rugs of Teec Nos Pos: Jewels of the Navajo Loom.* Albuquerque: Adobe Gallery, 1994.

Campbell, Tyrone D. *The Teec Nos Pos Regional Rug, 1905–1945.* Exhibition catalog, Scottsdale, AZ: Gallery 10, February 1990.

Coolidge, Dane, and Mary Roberts. *The Navajo Indians.* New York: Houghton Mifflin, 1930.

Hannon, Kerry. *Trees in a Circle: The Teec Nos Pos Story.* Teec Nos Pos Trading Post, 1999.

Hedlund, Ann L. *Reflections of the Weavers' World.* Denver: Denver Art Museum, 1992.

Hill, Willard W. "Navajo Trading and Trading Ritual: A Study of Cultural Dynamics." *Southwestern Journal of Anthropology* IV, no.4 (1948):371-396.

James, H.L. *Rugs and Posts: The Story of Navajo Rugs and Their Homes.* Globe, AZ: Southwest Parks and Monuments Association, 1976.

Kaufman, Alice, and Christopher Selser. *Navajo Weaving Traditions: 1650–Present.* New York: E.P. Dutton, 1985.

Kent, Kate Peck. *Navajo Weaving, Three Centuries of Change.* Santa Fe, NM: School of American Research, 1985.

McNitt, Frank. *The Indian Traders.* Norman: University of Oklahoma Press, 1962.

Maxwell, Gilbert. *Navajo Rugs: Past, Present and Future.* Palm Desert, CA: Best West Publications, 1963.

Steckel, Carl. *A Brief History of an Early Day Trader with the Navajos.* El Paso: publisher unknown, 1987.

Utley, Robert M. "The Reservation Trader in Navajo History." In *El Palacio* 68, no. 1 (1961):5-27.

Weeks, Jennie N., Betty N. McGee, and Martha N. Wilson. *Emigrant Cornelius Noel: From Holland to Virginia and his Descendants in America.* Vol. V, Part IV, Book II. Salt Lake City: publisher unknown, 1980.